Mandala Coloring Book V.7

Therapy for Many Diseases

Andrea T. Cross

Copyright © 2019 Andrea T. Cross

All rights reserved.

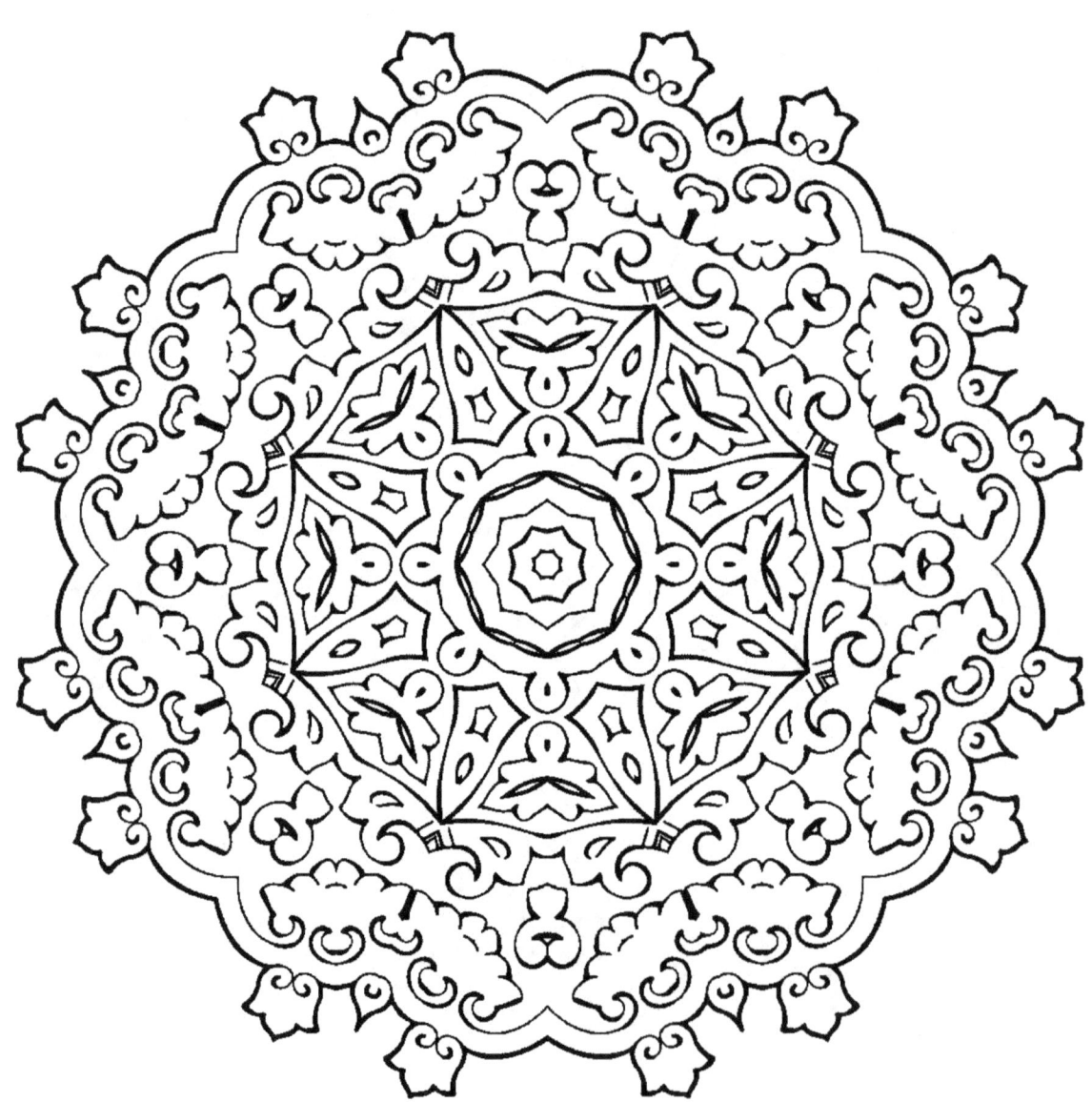

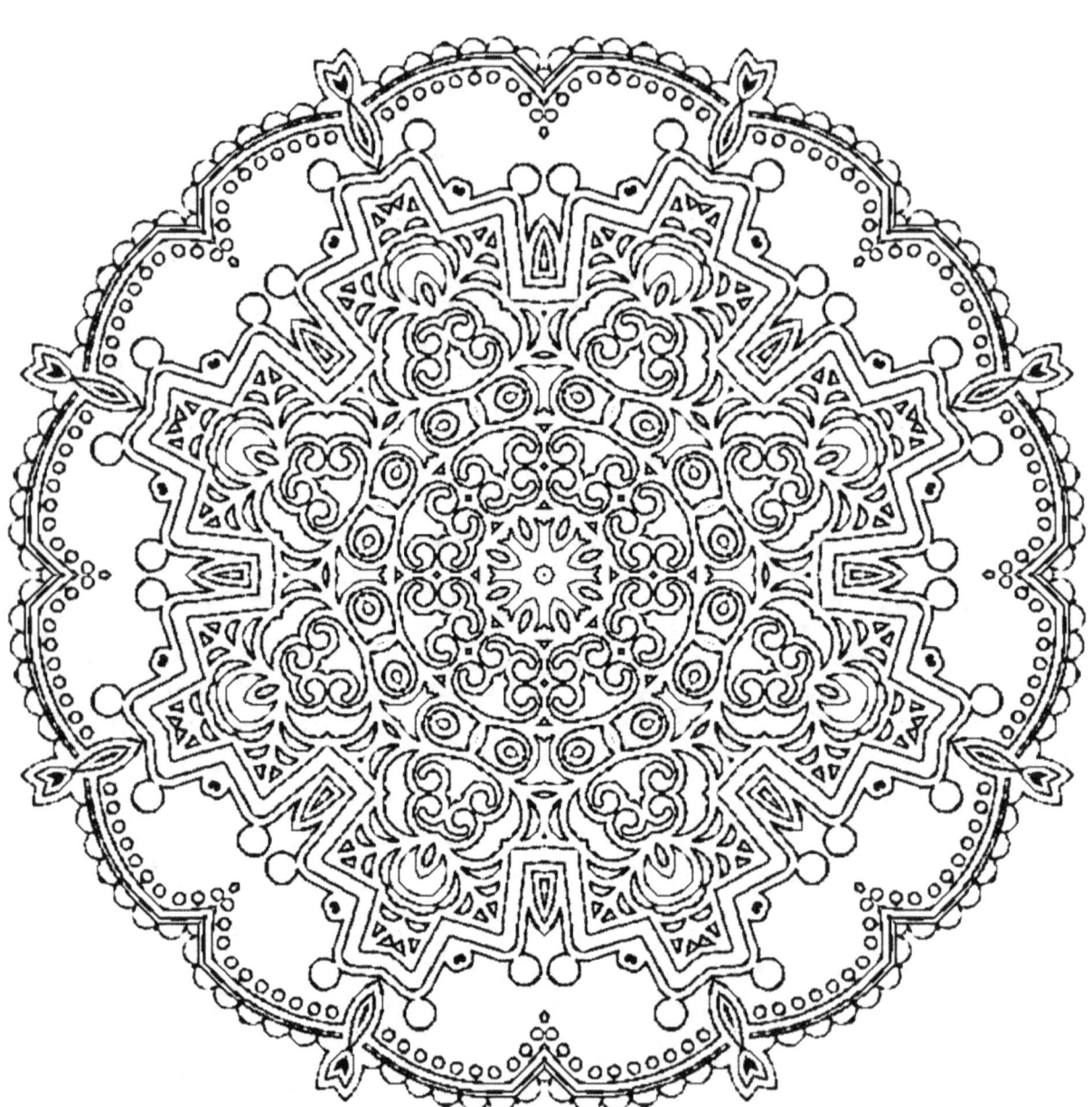

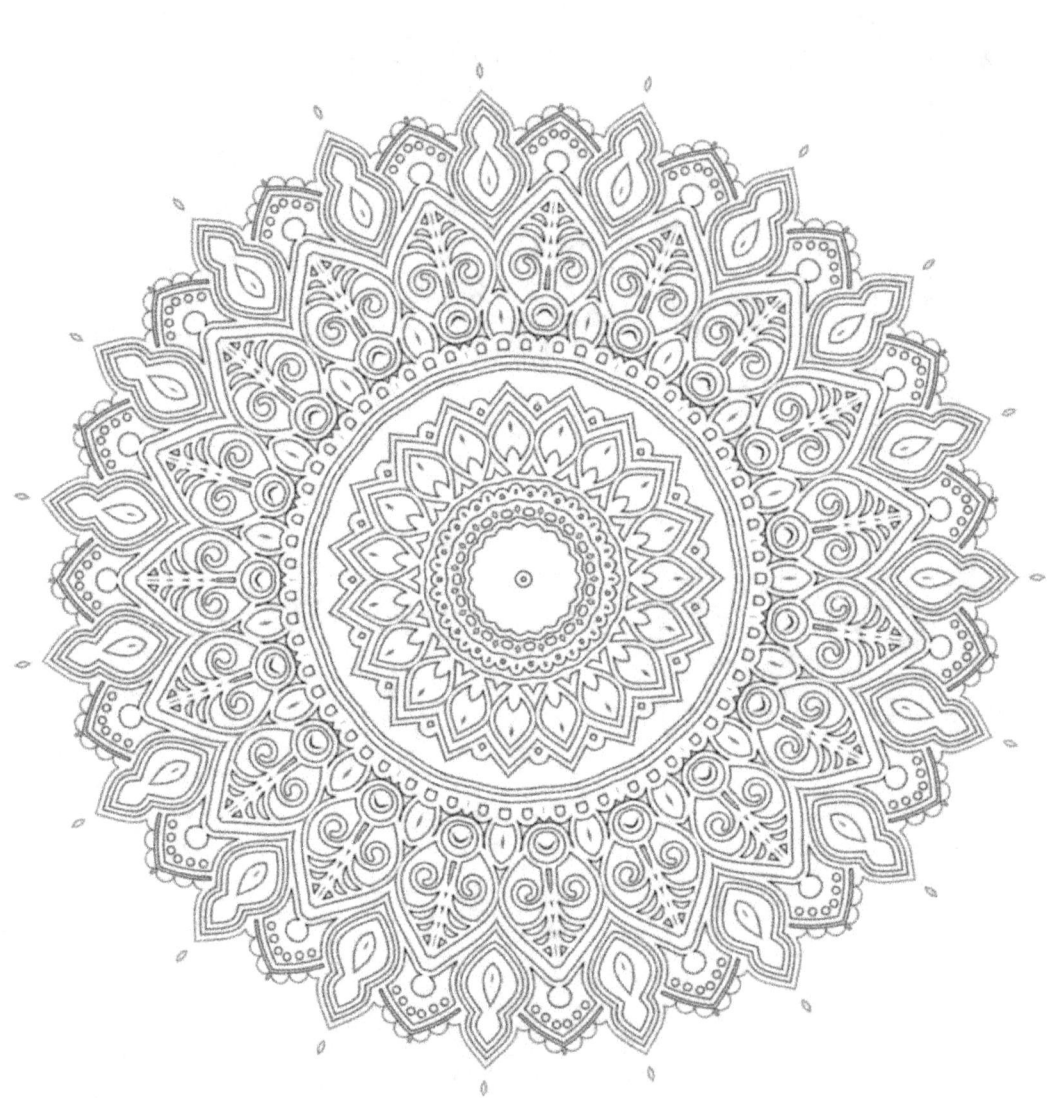

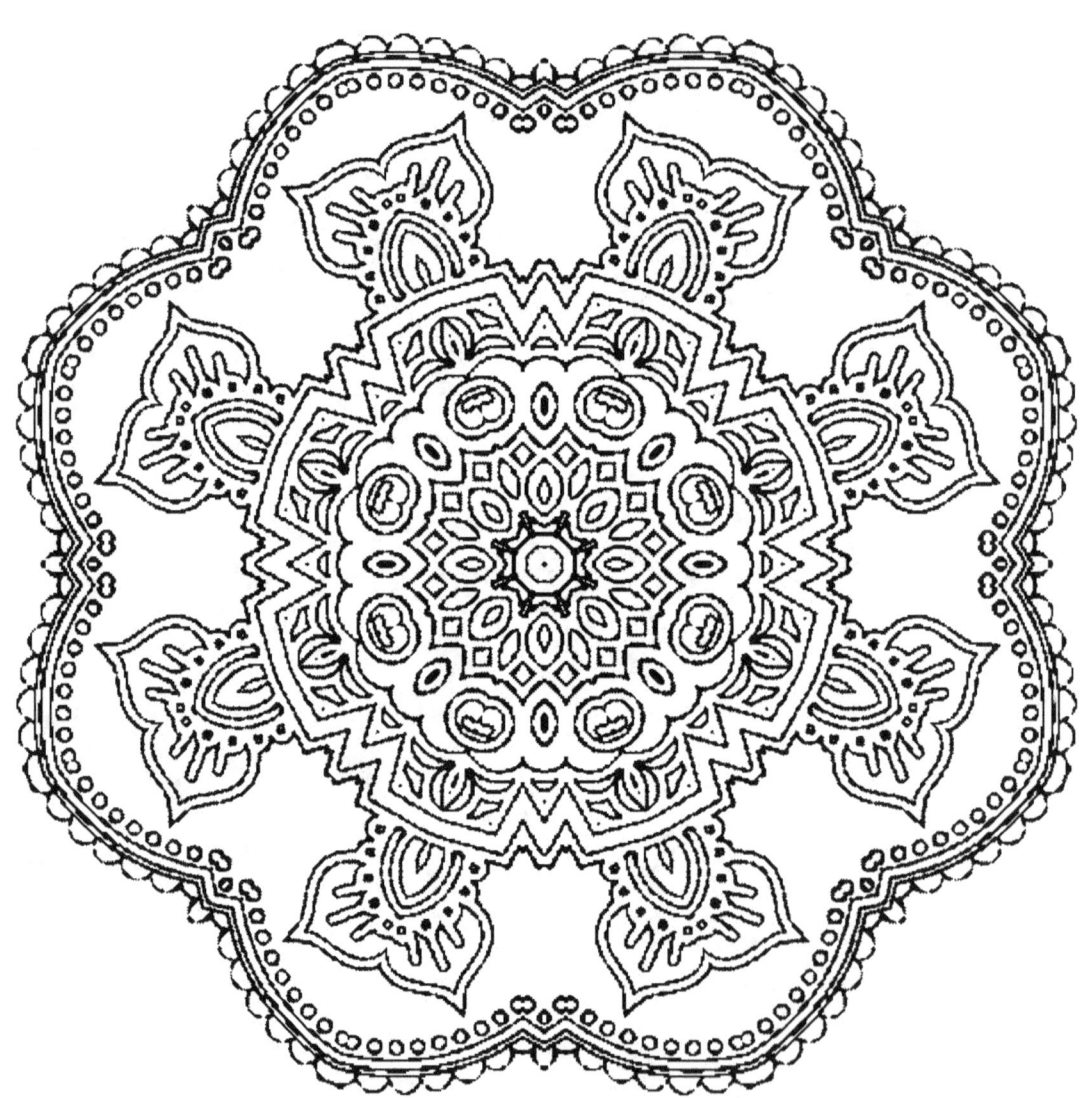

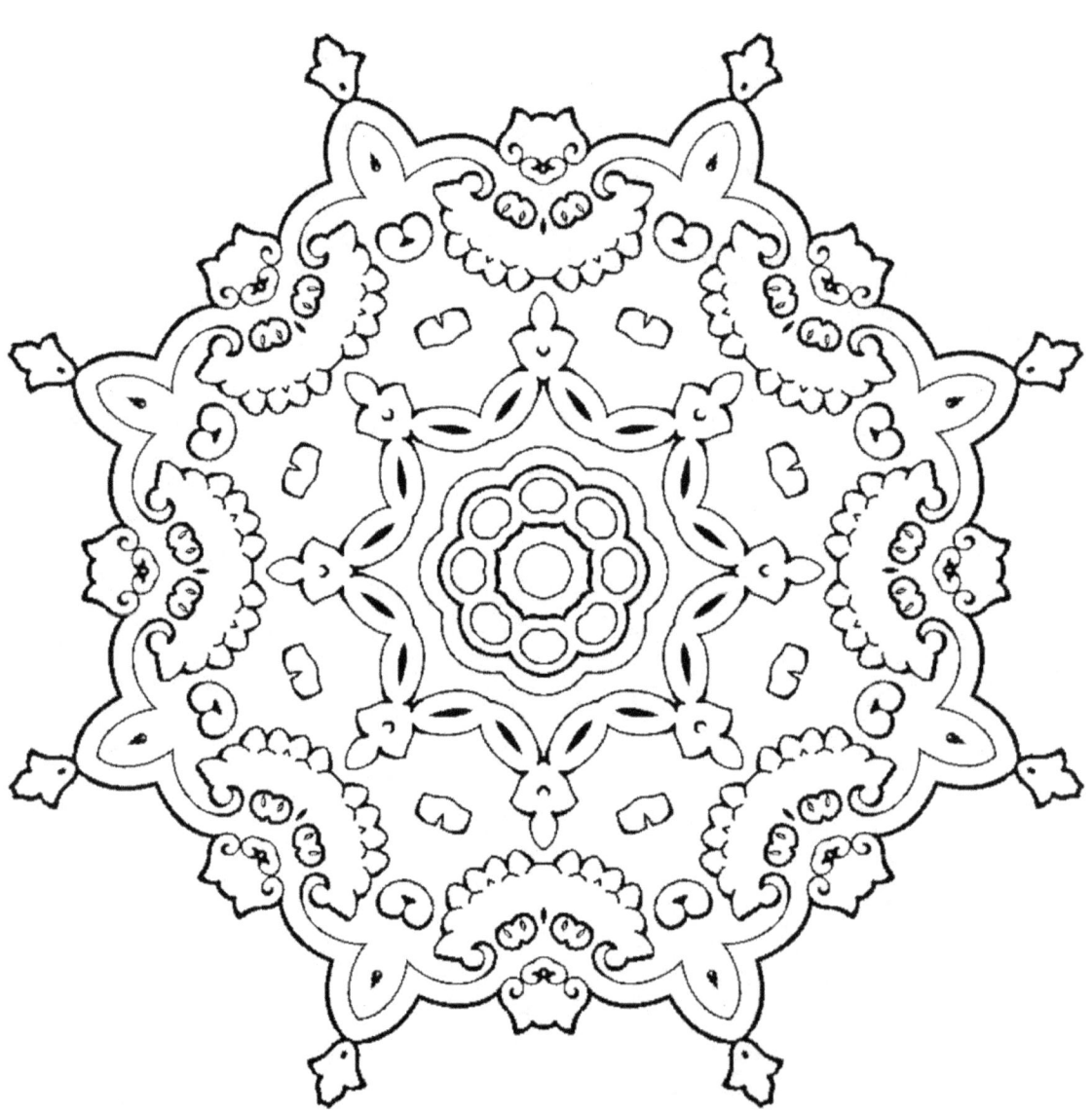

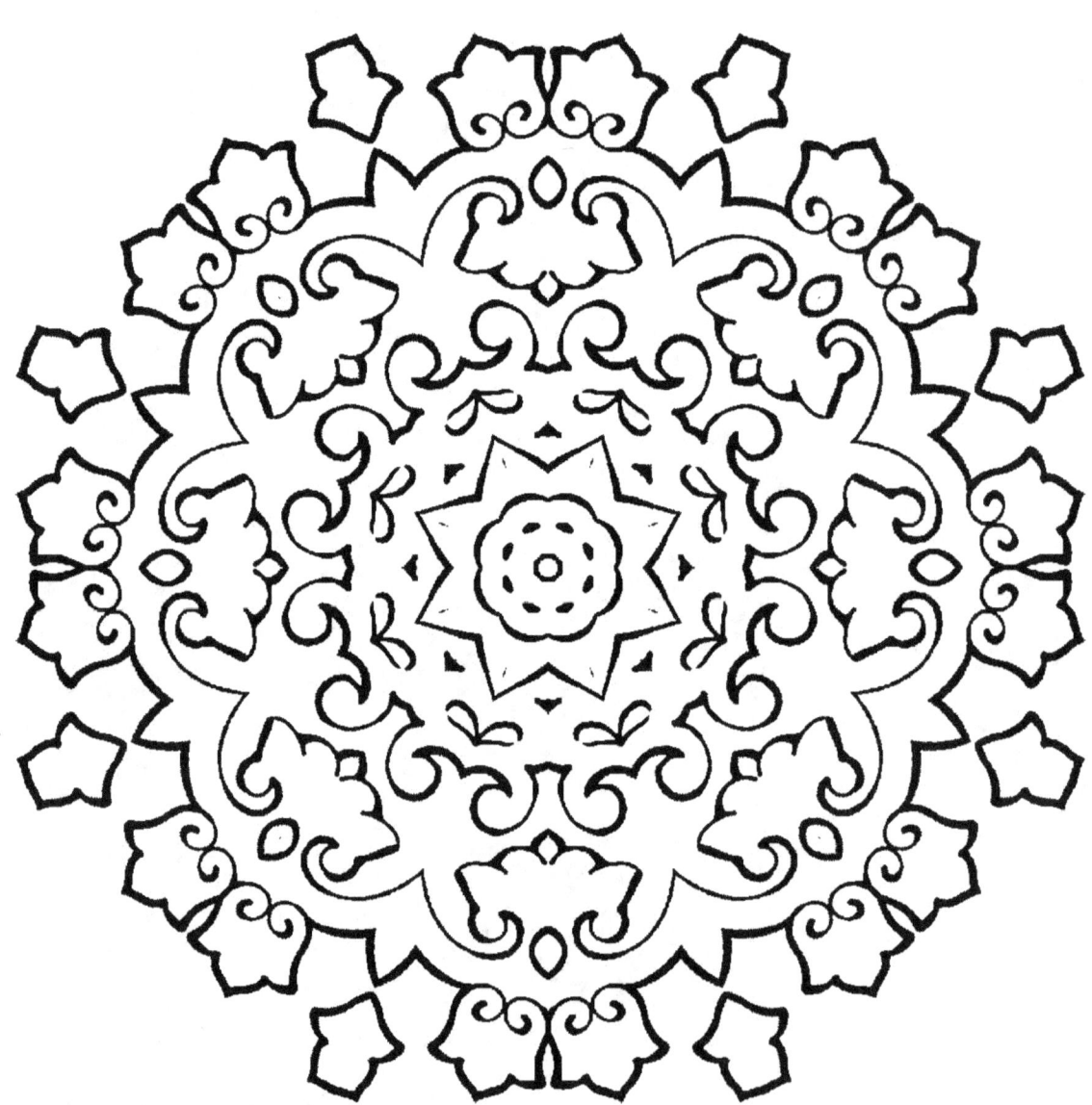

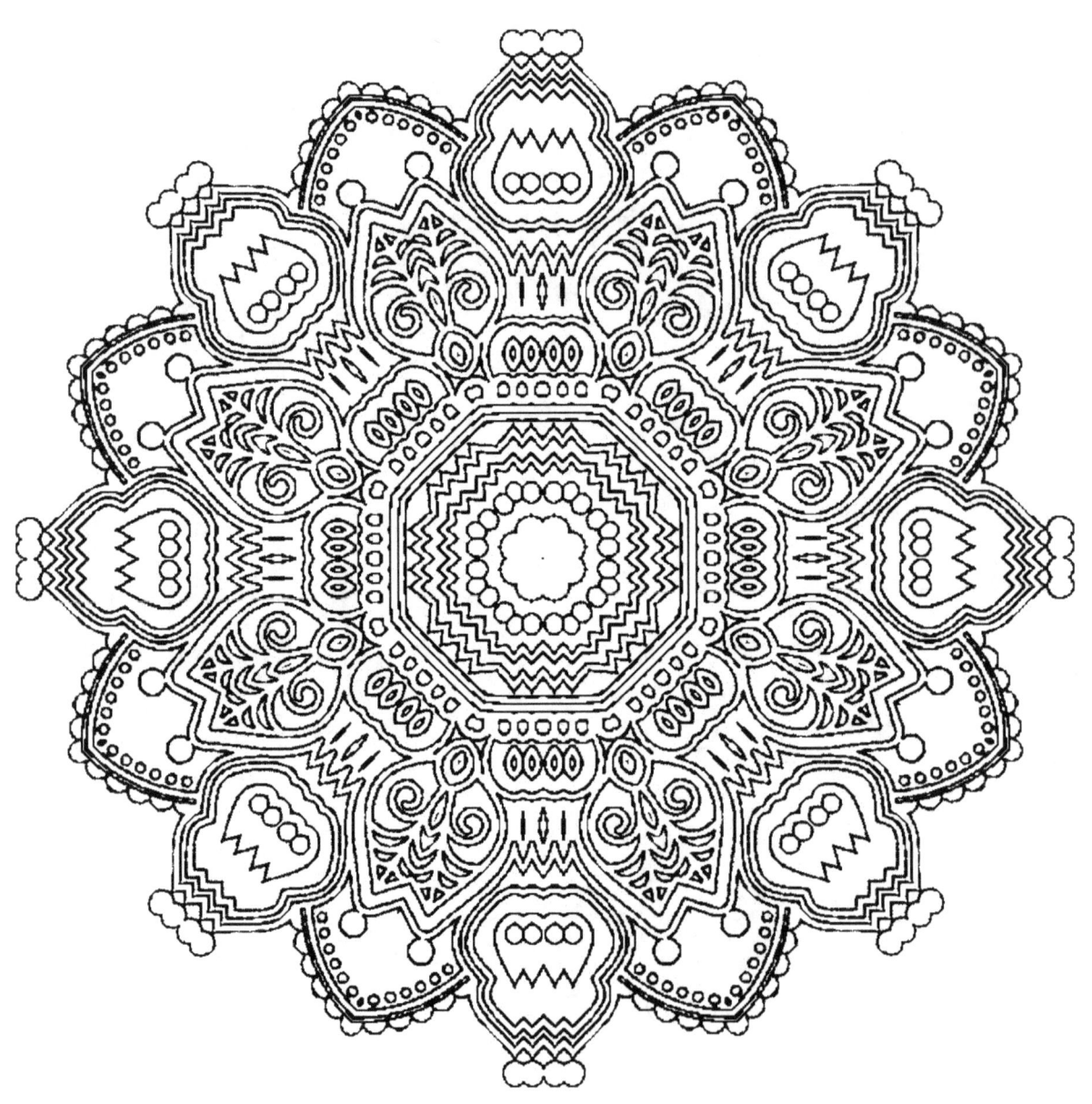

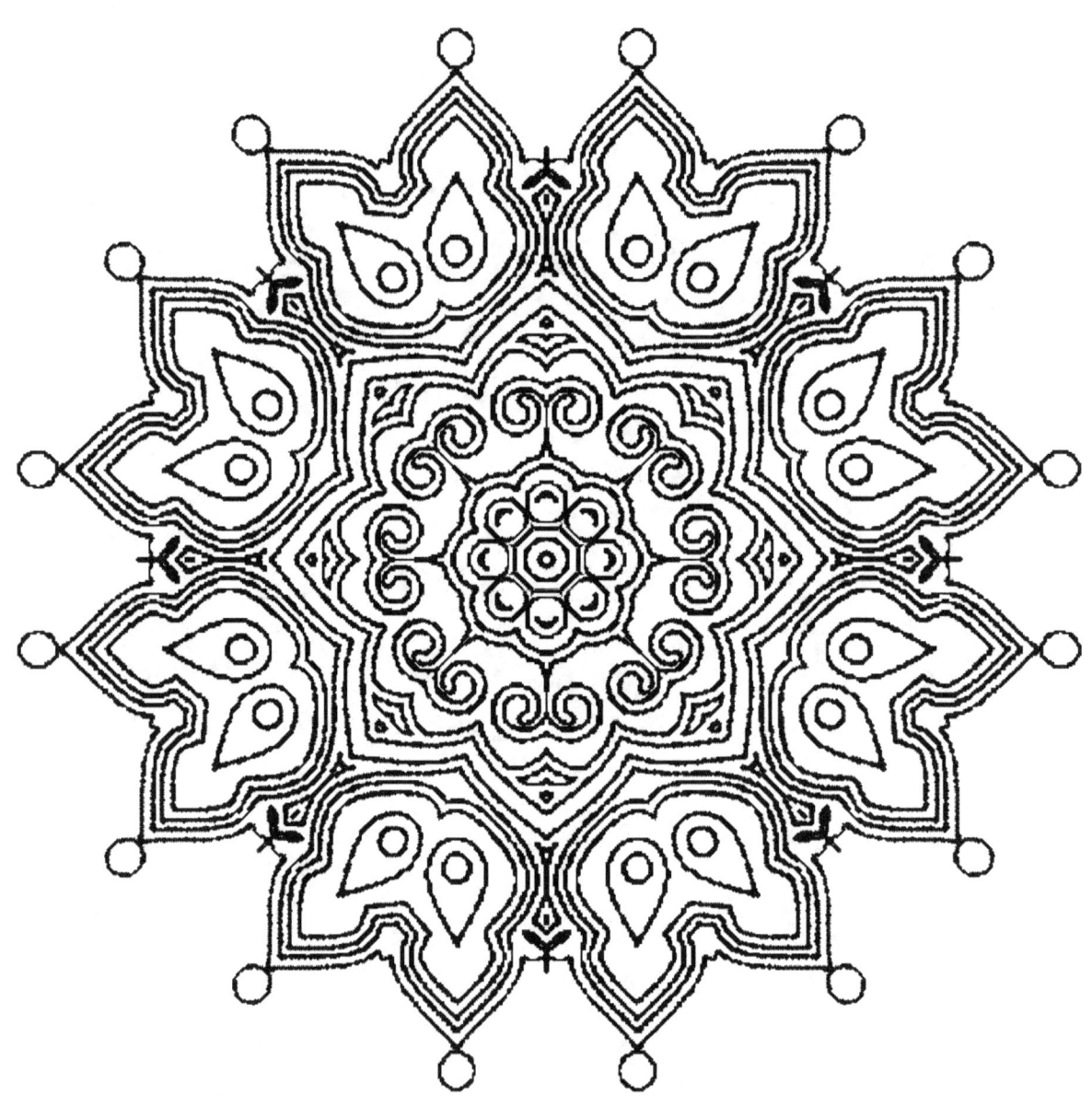

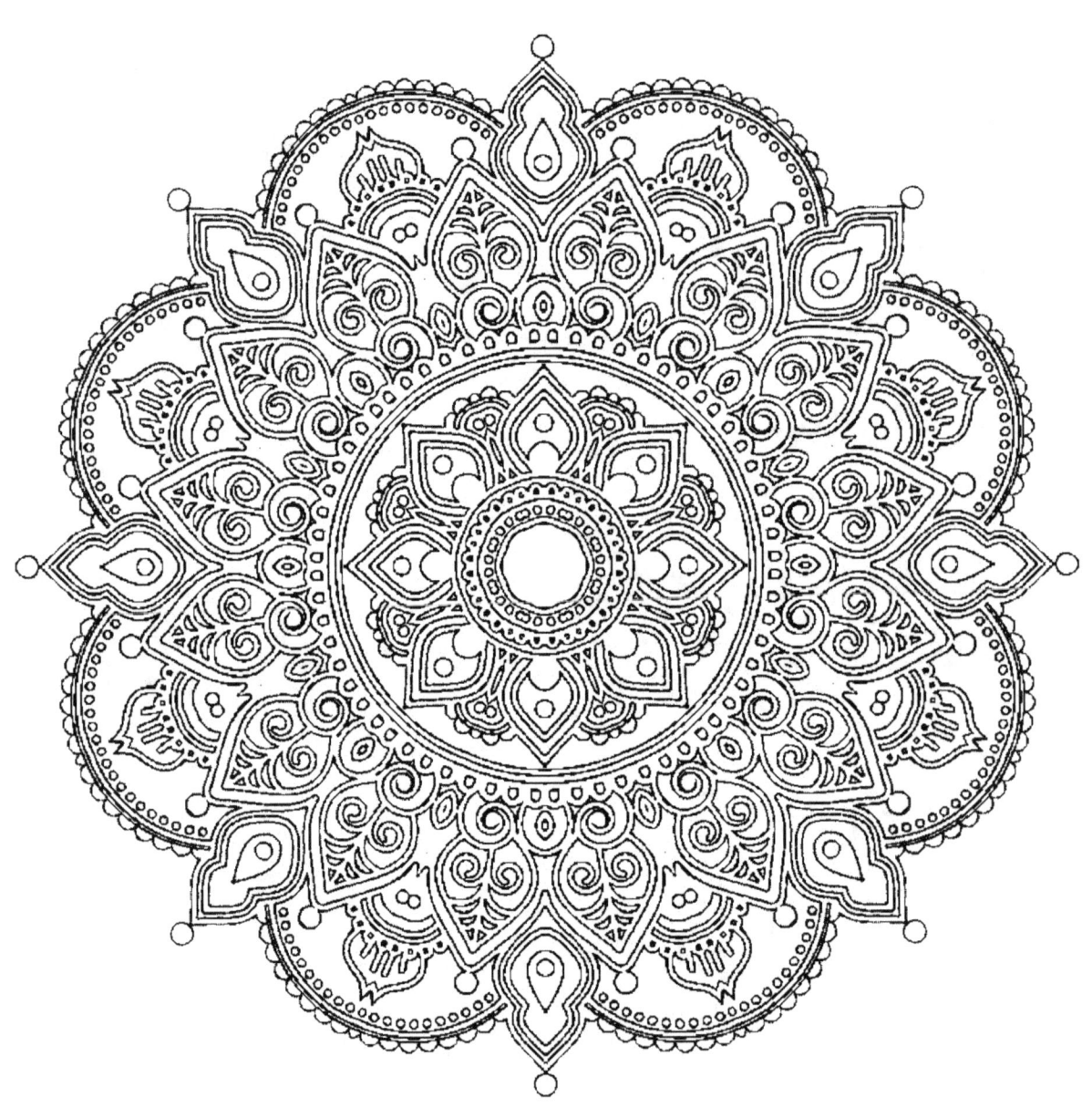

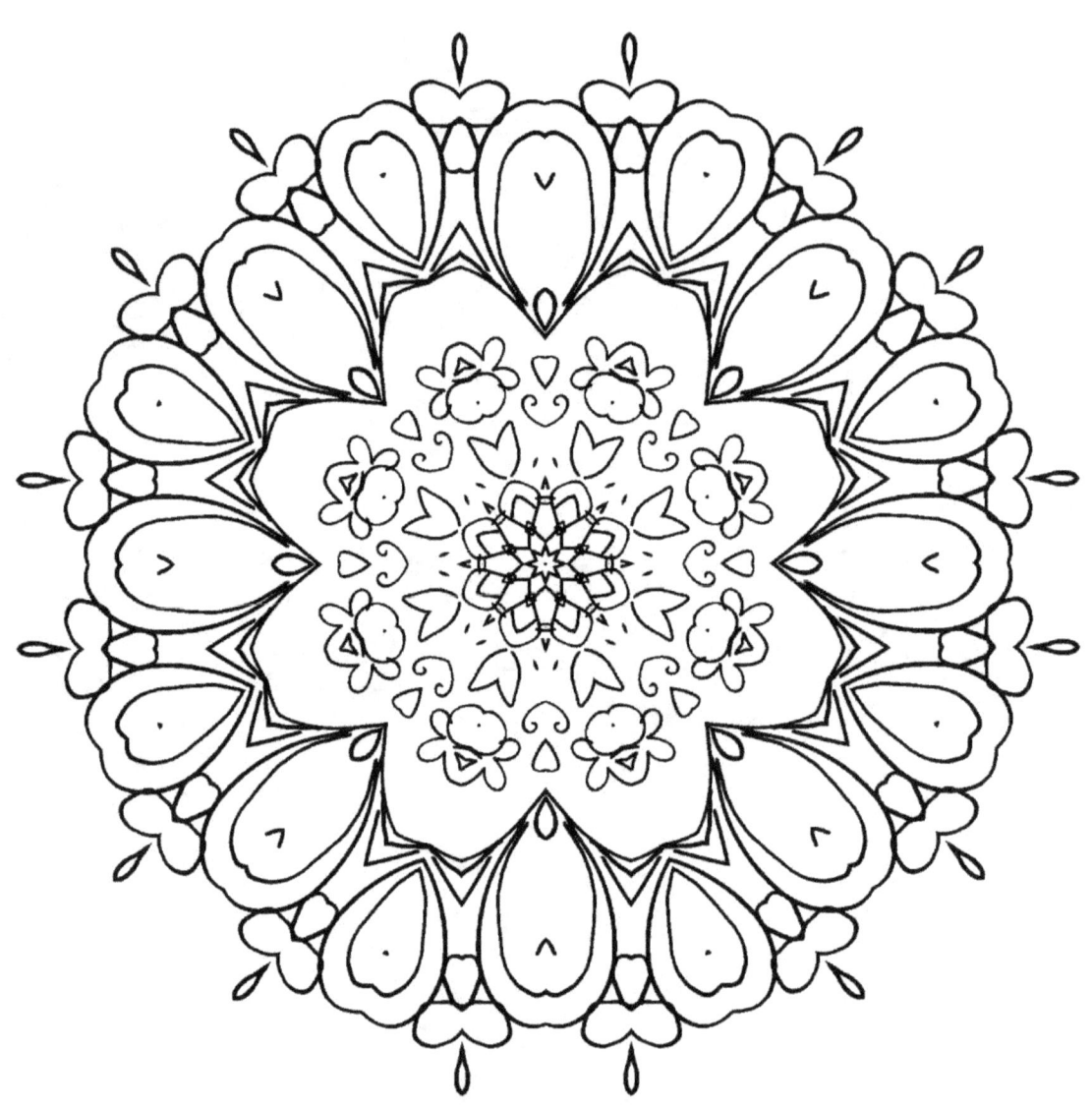

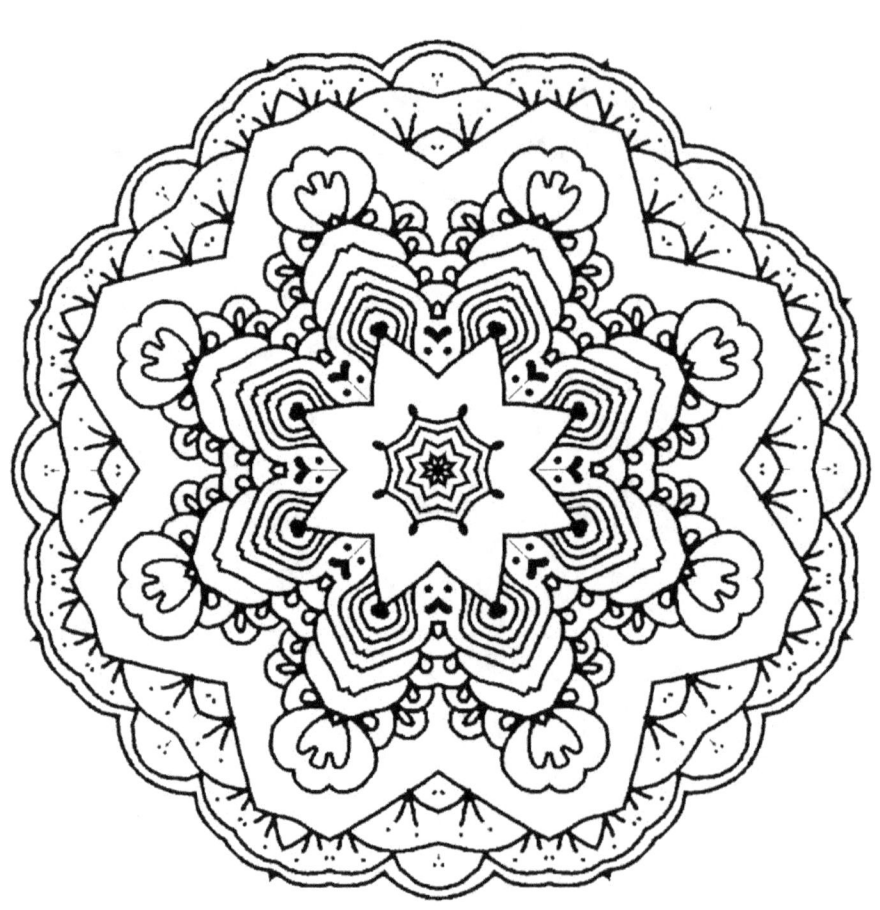

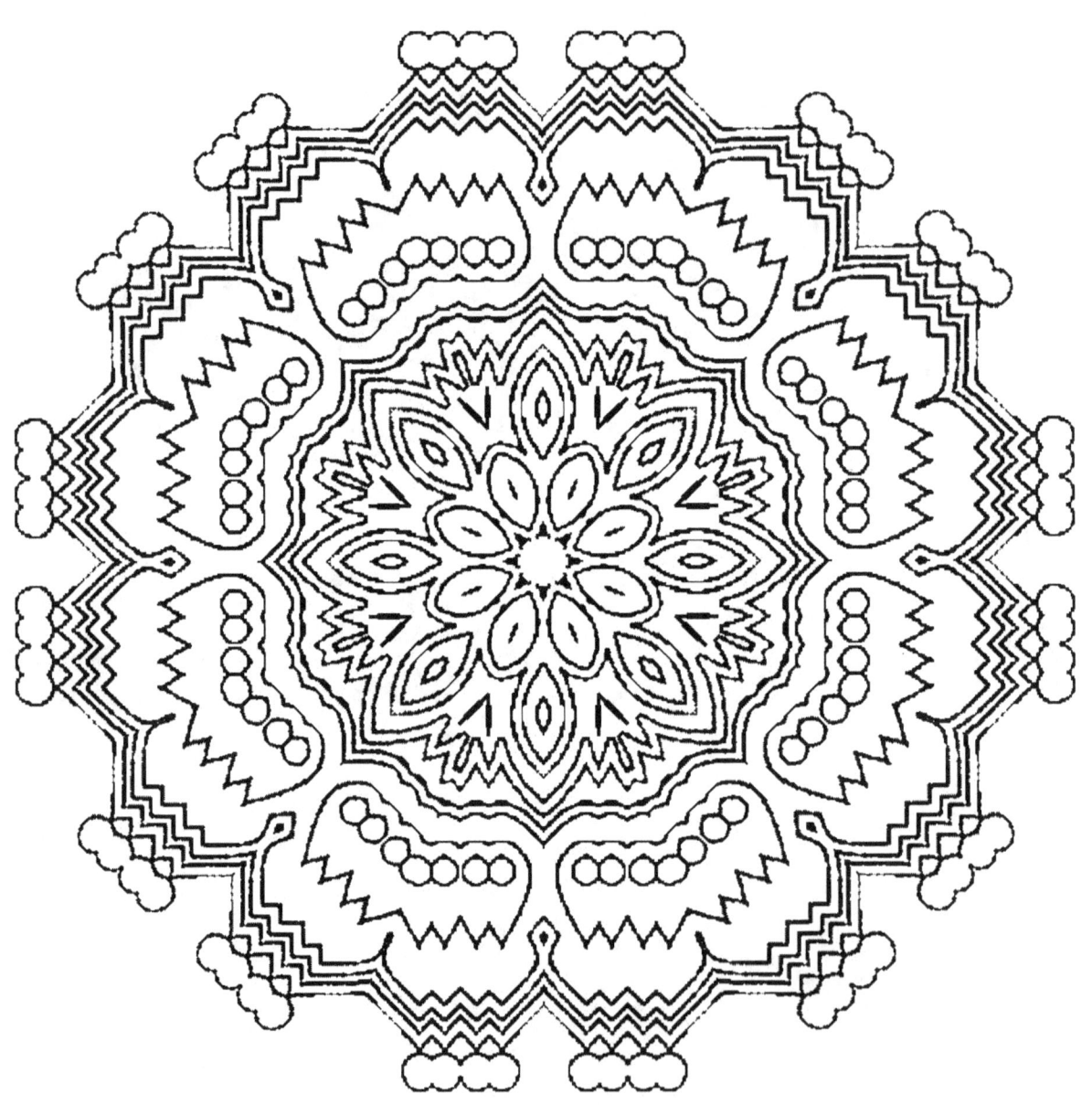

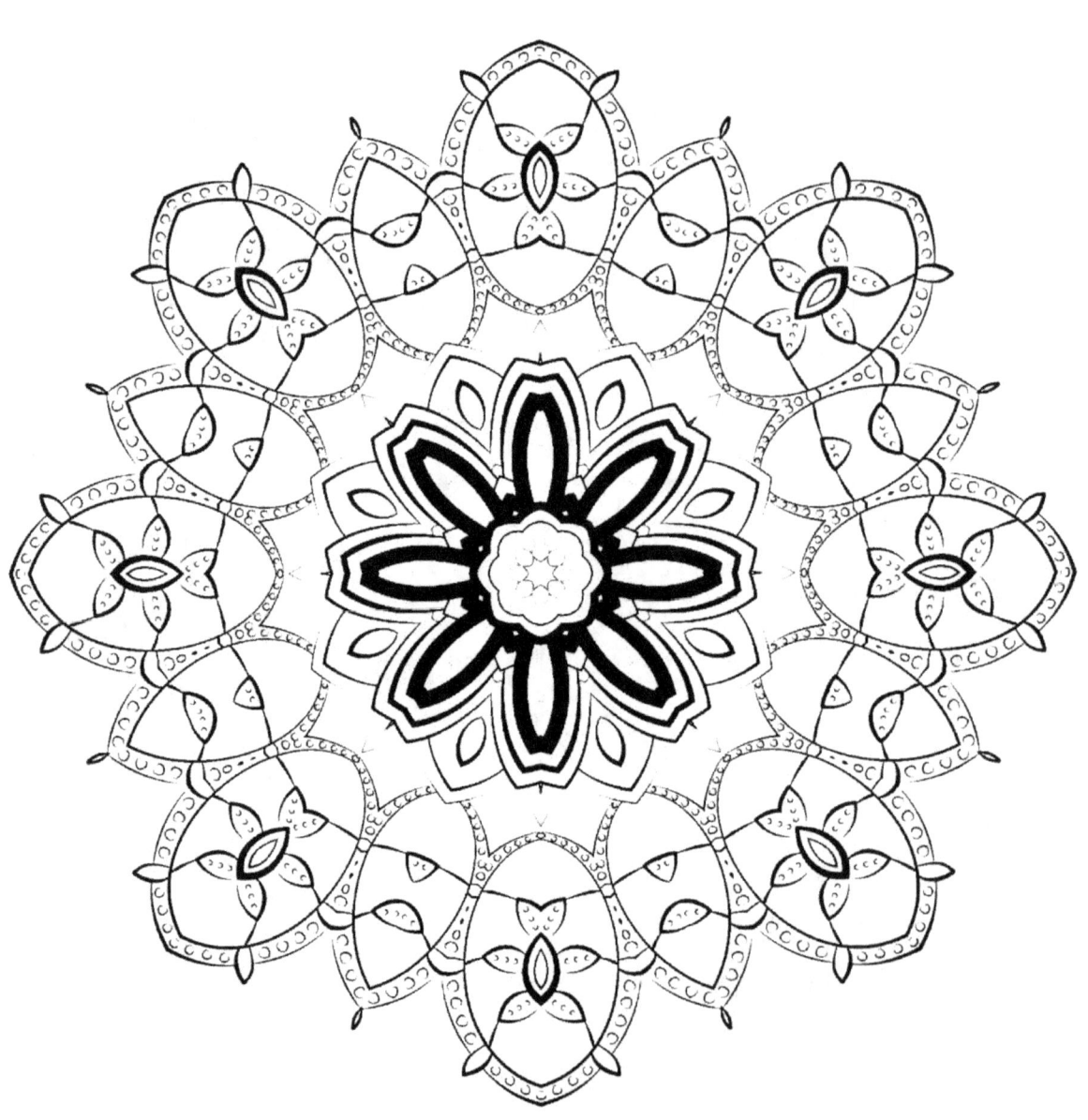

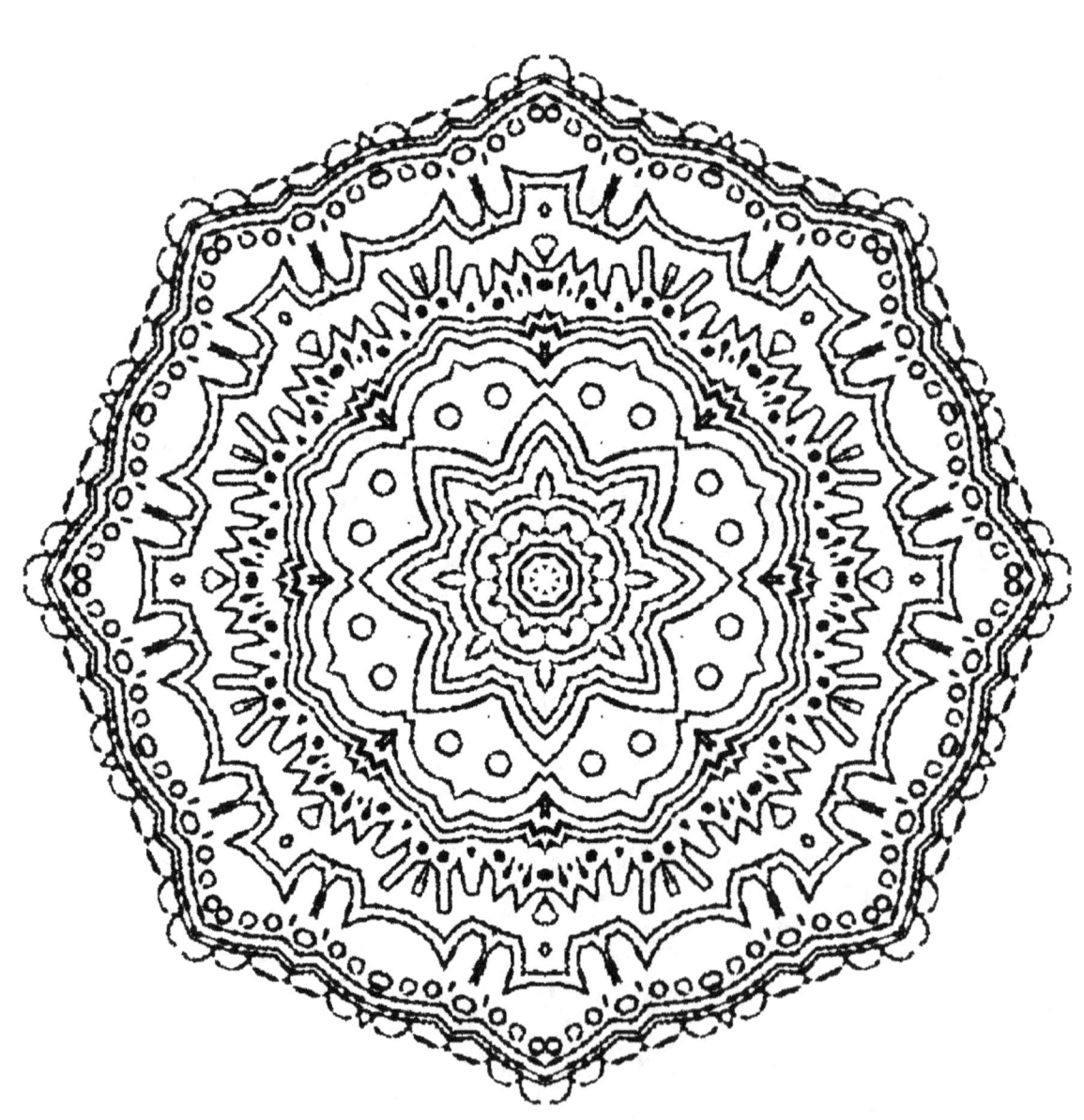

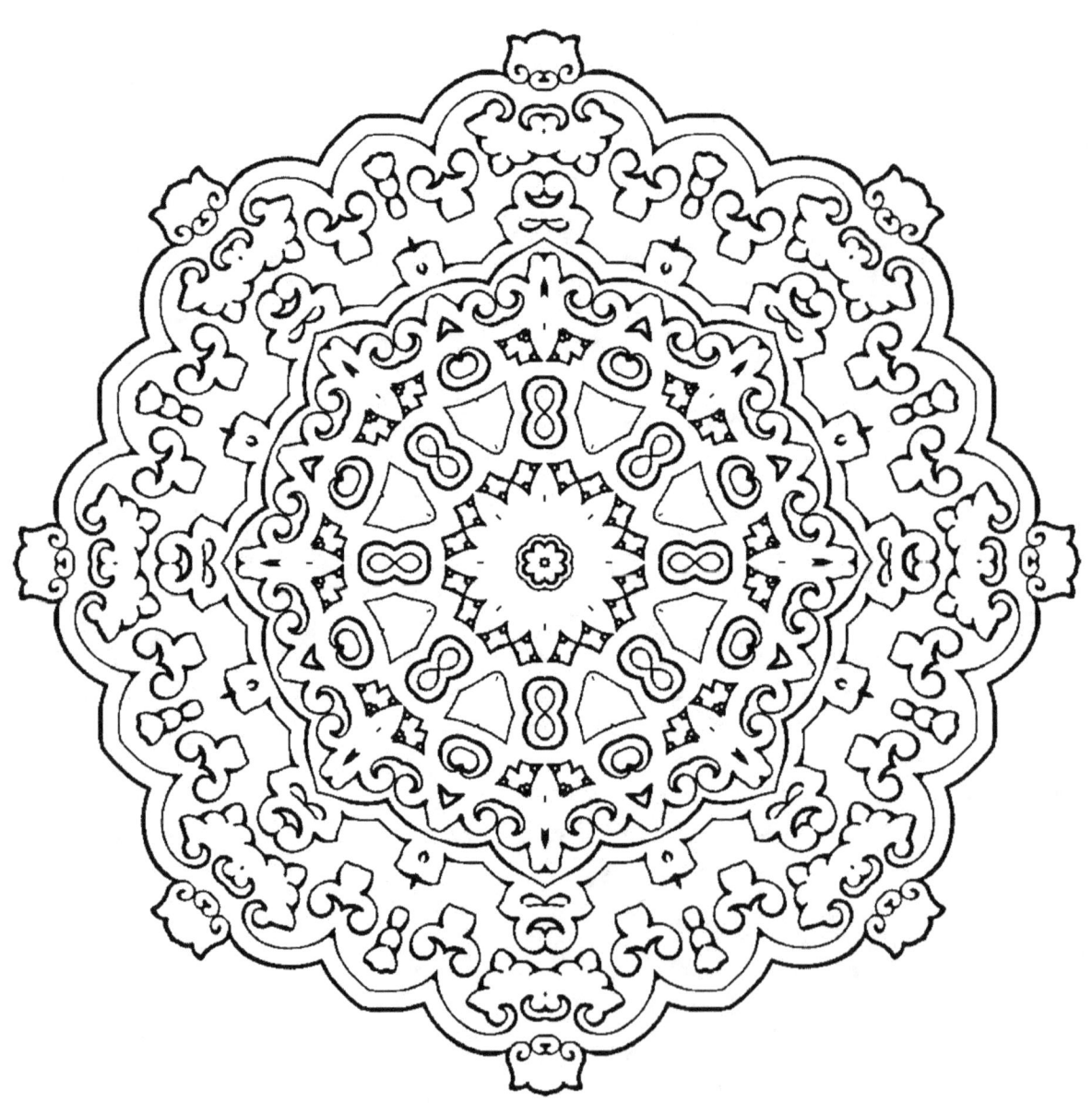

www.ingramcontent.com/pod-product-compliance
Lightning Source LLC
Chambersburg PA
CBHW080818220526
45466CB00011BB/3605